This book belongs to

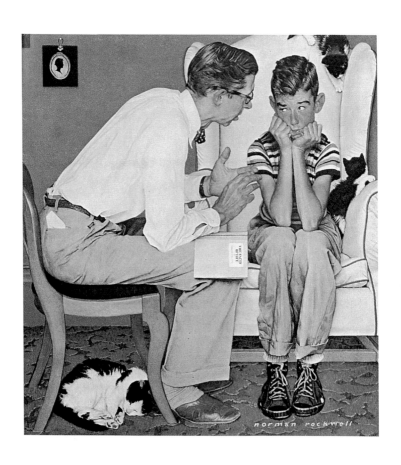

An American Family Album

NORMAN ROCKWELL

ARIEL BOOKS

ANDREWS AND McMEEL

KANSAS CITY

Frontispiece: THE FACTS OF LIFE
Saturday Evening Post cover, July 14, 1951

Book design by Susan Hood

An American Family Album

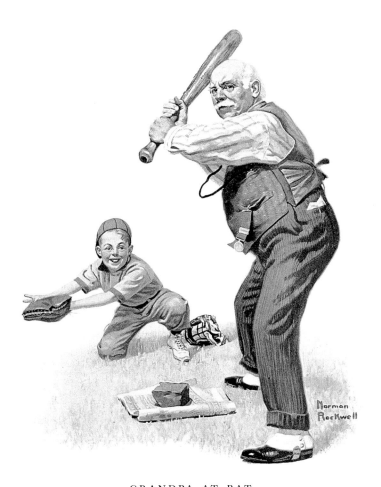

GRANDPA AT BAT

Saturday Evening Post cover
August 5, 1916

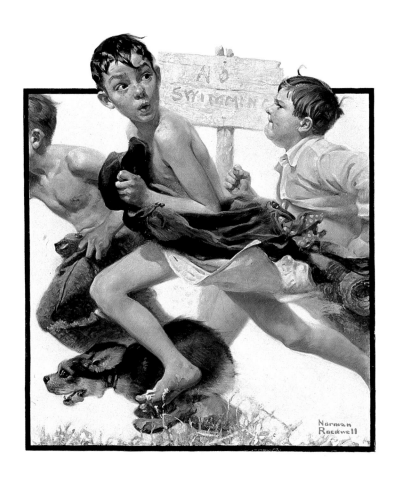

NO SWIMMING

—

Saturday Evening Post cover
June 4, 1921

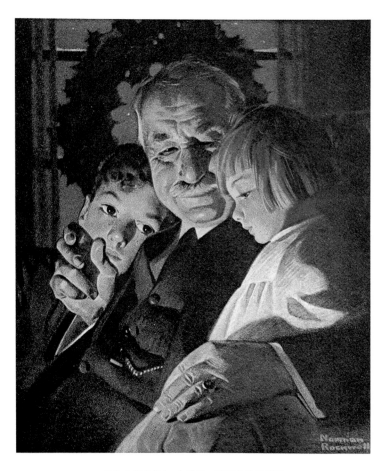

GRANDPA AND CHILDREN

Literary Digest cover
December 24, 1921

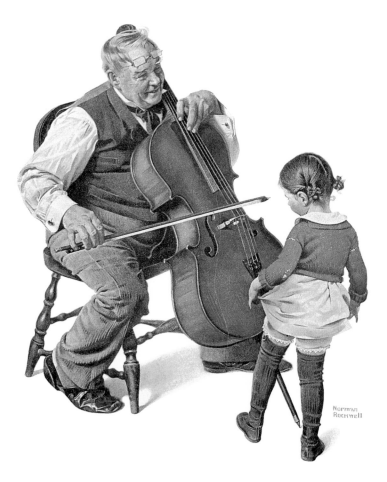

THE ACCOMPANIST

Saturday Evening Post cover
February 3, 1923

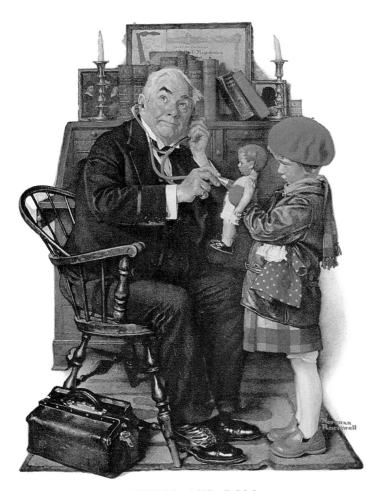

DOCTOR AND DOLL

Saturday Evening Post cover
March 9, 1929

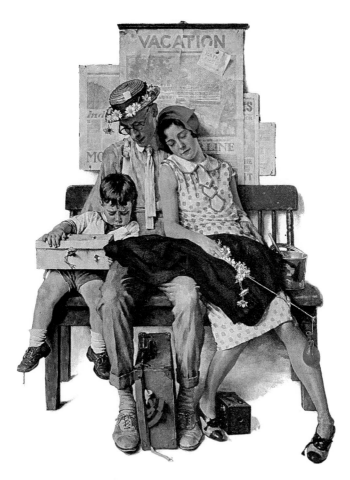

HOME FROM VACATION

Saturday Evening Post cover
September 13, 1930

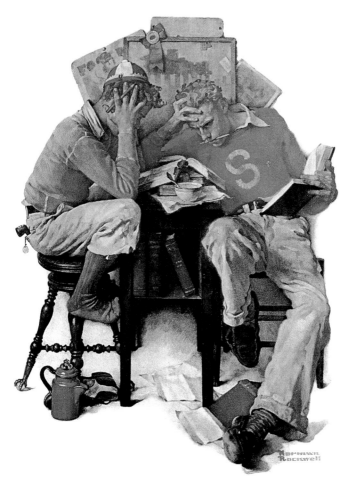

CRAMMING

Saturday Evening Post cover
June 13, 1931

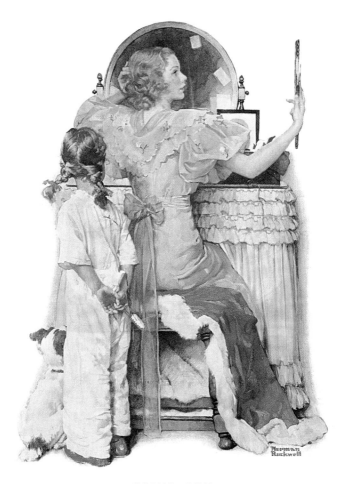

GOING OUT

Saturday Evening Post cover
October 21, 1933

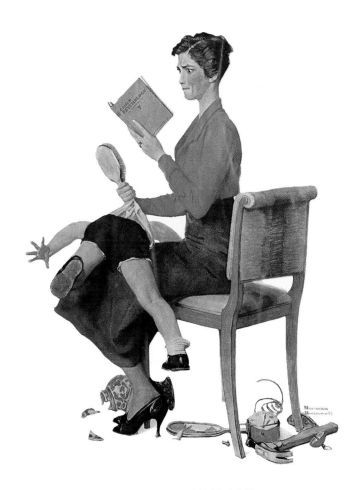

CHILD PSYCHOLOGY

—

Saturday Evening Post cover
November 25, 1933

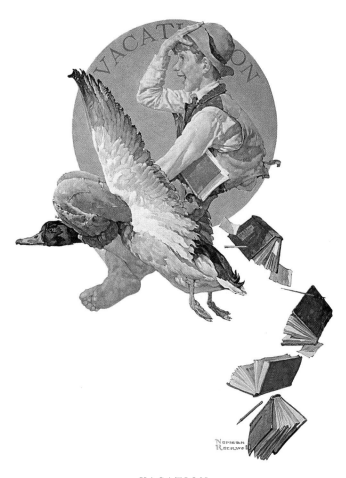

VACATION

Saturday Evening Post cover
June 30, 1934

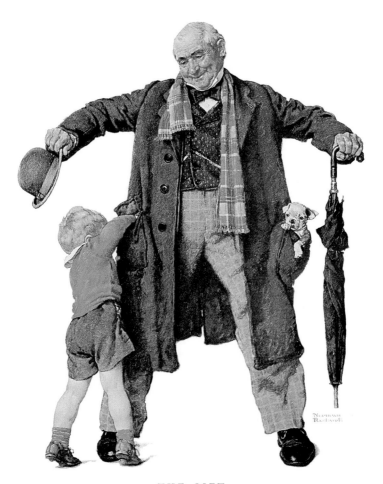

THE GIFT

Saturday Evening Post cover
January 25, 1936

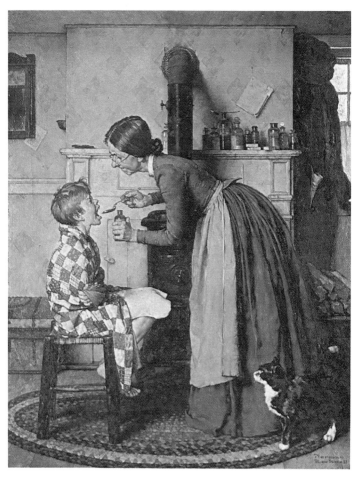

MEDICINE TIME

Saturday Evening Post cover
May 30, 1936

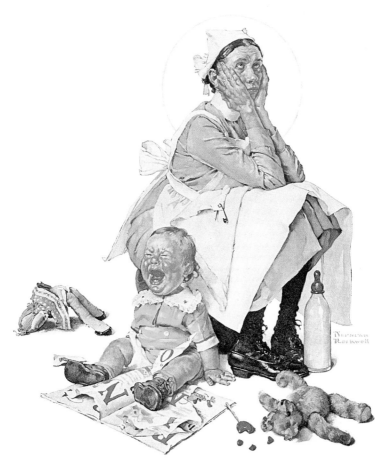

THE NANNY

Saturday Evening Post cover
October 24, 1936

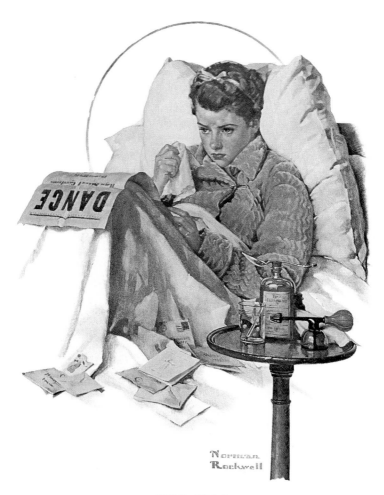

THE COLD

Saturday Evening Post cover
January 23, 1937

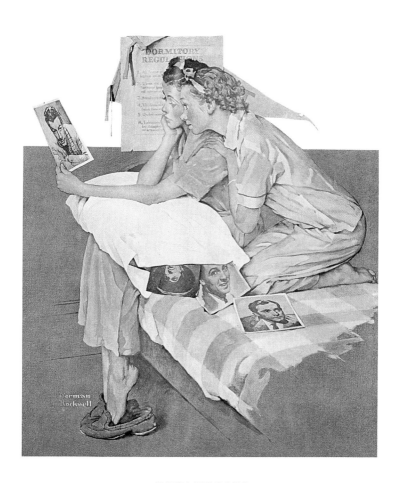

DREAMBOATS

Saturday Evening Post cover
February 19, 1938

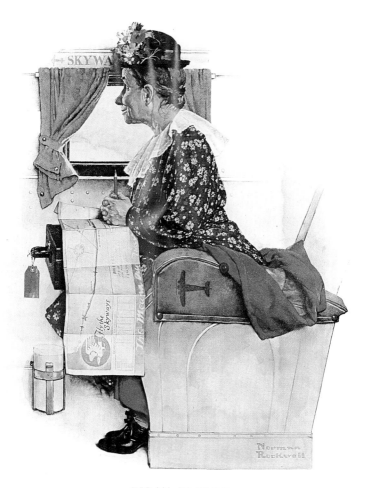

FIRST FLIGHT

Saturday Evening Post cover
June 4, 1938

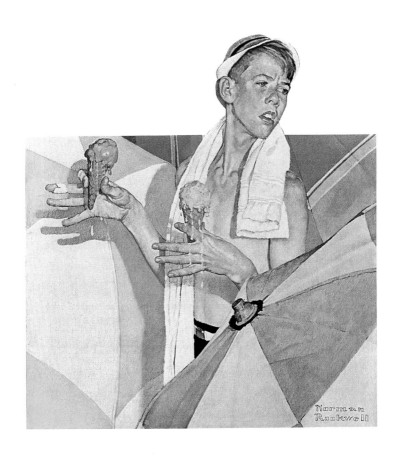

AT THE BEACH

Saturday Evening Post cover
July 13, 1940

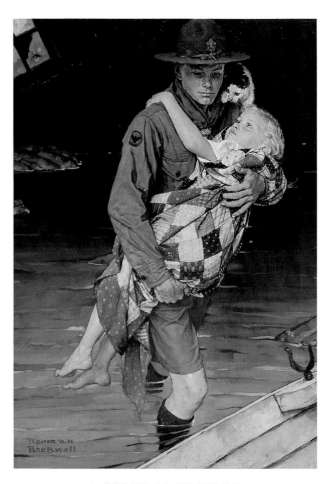

A SCOUT IS HELPFUL

Boy's Life cover
February, 1942

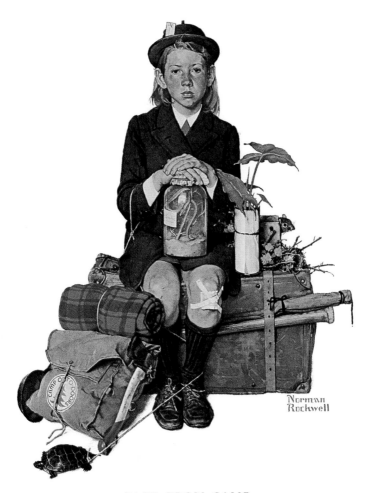

BACK FROM CAMP

Saturday Evening Post cover
August 24, 1940

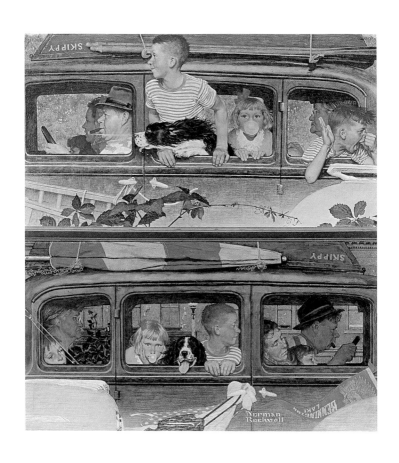

FAMILY OUTING

———

Saturday Evening Post cover
August 30, 1947

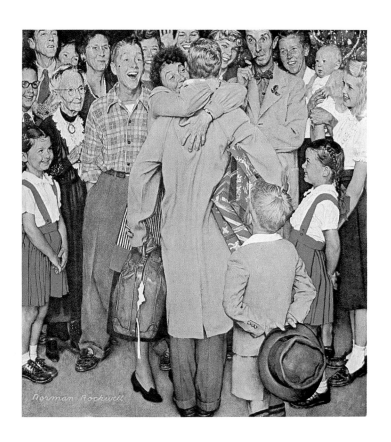

IT'S GOOD TO BE HOME!

Saturday Evening Post cover
December 25, 1948

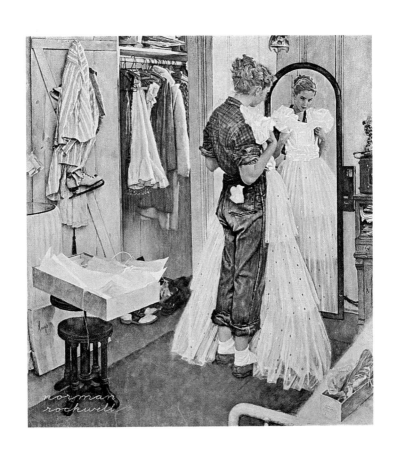

PROM DRESS

Saturday Evening Post cover
March 19, 1949

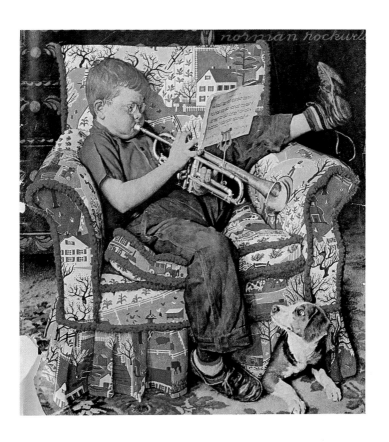

PRACTICE

—

Saturday Evening Post cover
November 18, 1950

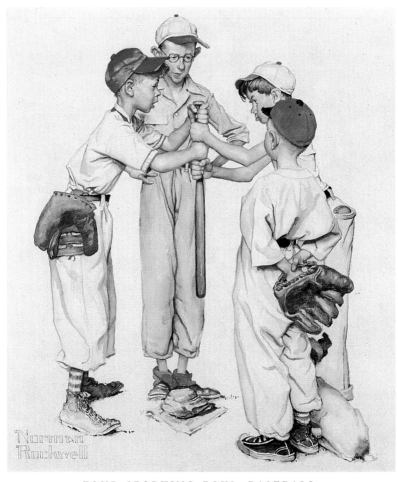

FOUR SPORTING BOYS: BASEBALL

Brown & Bigelow
1951 Four Seasons Calendar, Spring

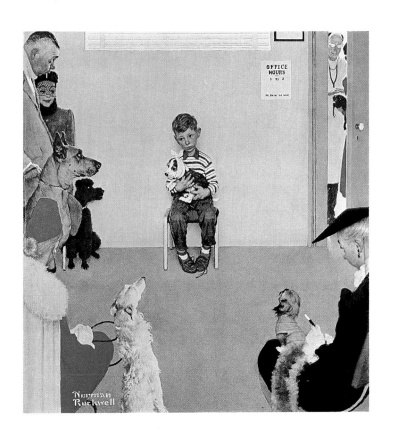

AT THE VET'S

—

Saturday Evening Post cover
March 29, 1952

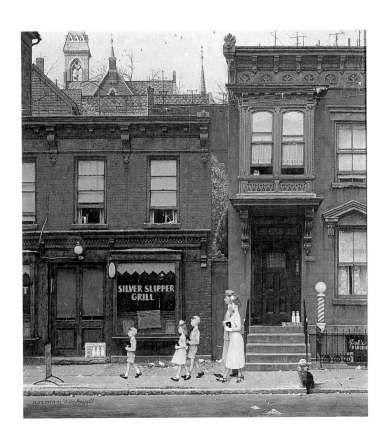

WALKING TO CHURCH

—

Saturday Evening Post cover
April 4, 1953

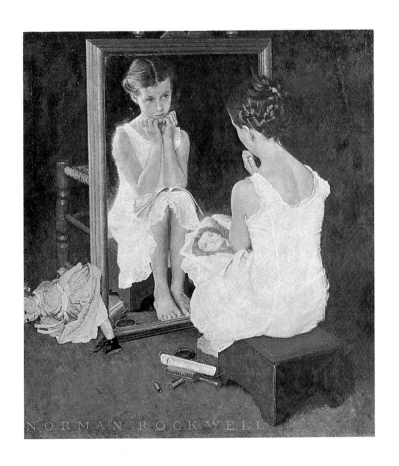

GIRL IN THE MIRROR

Saturday Evening Post cover
March 6, 1954

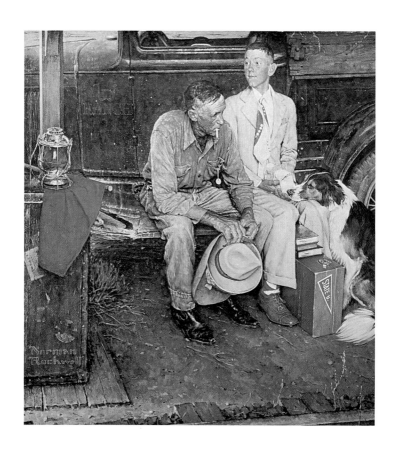

LEAVING HOME

Saturday Evening Post cover
September 25, 1954

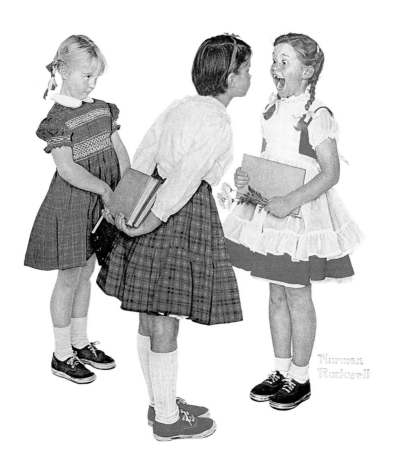

THE LOST TOOTH
———

Saturday Evening Post cover
September 7, 1957

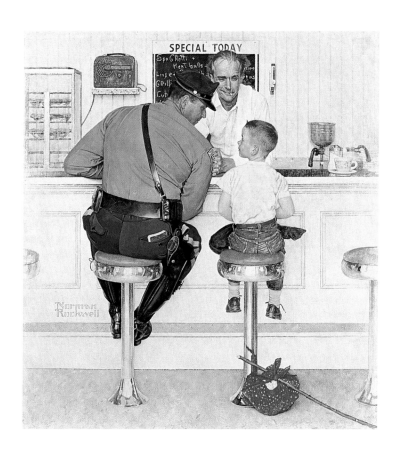

THE RUNAWAY

Saturday Evening Post cover
September 20, 1958

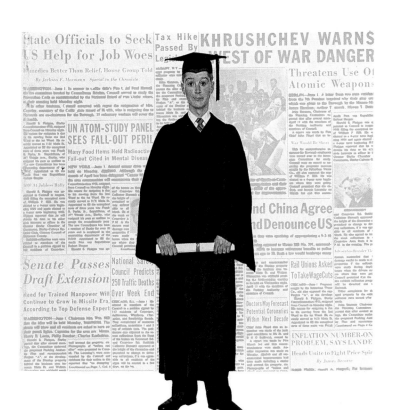

THE GRADUATE

Saturday Evening Post cover
June 6, 1959

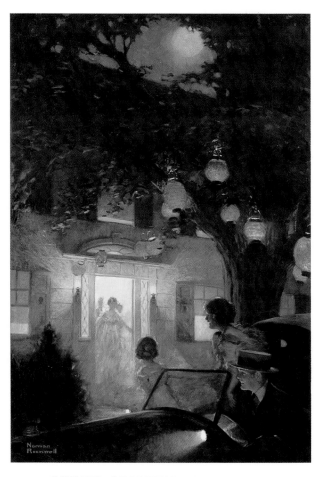

GUESTS ARRIVING AT A PARTY

—

Saturday Evening Post cover
August 7, 1920

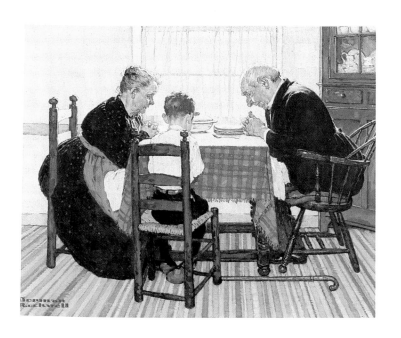

FAMILY GRACE

Ladies' Home Journal
August, 1938